Wood, Ink & Paper

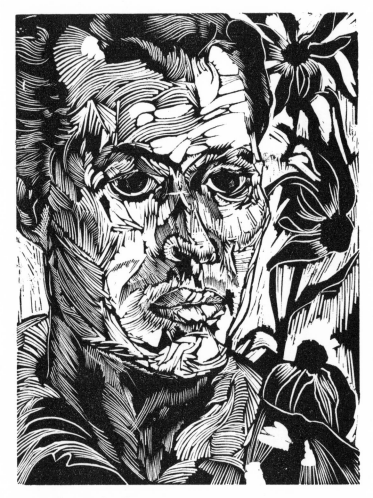

G. Brender à Brandis, self-portrait

G. Brender à Brandis

Wood, Ink & Paper

Gerard Brender à Brandis

The Porcupine's Quill, Incorporated

Published by The Porcupine's Quill, Inc., 68 Main Street, Erin, Ontario NOB 1TO. Financial assistance towards publication was extended by both the Canada Council and the Ontario Arts Council, whose support is gratefully acknowledged.

Designed by Tim and Elke Inkster. Printed and bound by The Porcupine's Quill, Inc. The type is Cartier, composed at The Coach House Press (Toronto), and the stock is Zephyr laid.

ISBN 0-88984-029-6 paper

7th printing, 1997.

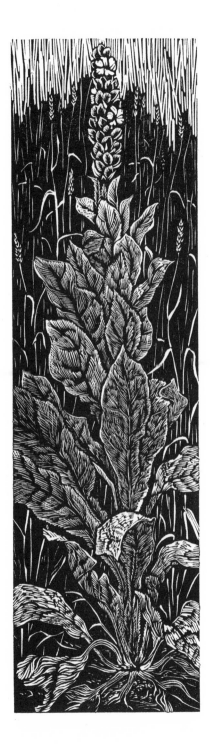

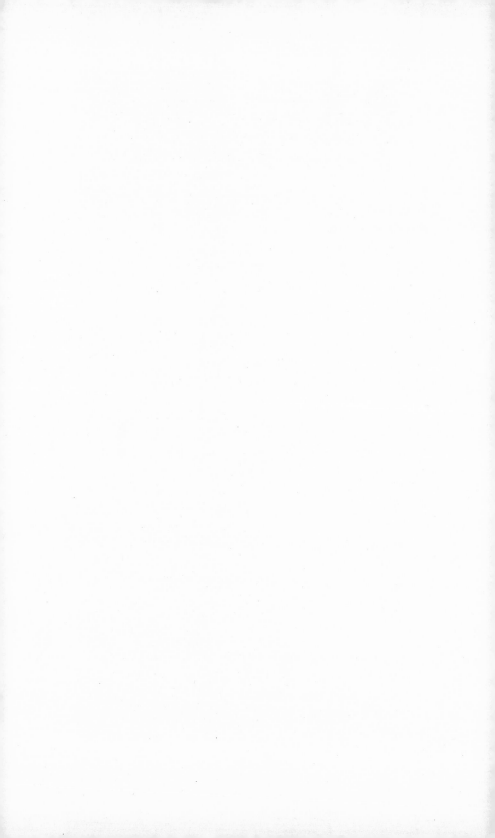

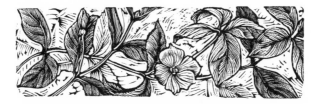

The craft of printing designs from wooden blocks may have
been brought by the Mongol invaders from China to the
Near East and then by the Moslems or Crusaders to Western
Europe, or it may have been invented quite independently
by a European carver who saw the application of his craft to
supplying the demand for printed fabrics and playing cards
created by the increase of culture and trade in the later
Middle Ages. In any case, it was being used in the early
fifteenth century for printing books, a block being used for
each page. It was Johannes Gutenberg's contribution to
realize that, if each block had only one letter on it, the
blocks used to make up a page could be re assembled to
compose another. But the use of the wood block did not
disappear from printing when Gutenberg replaced wood
with cast metal. It remained the material for large initials,
borders and illustrations. In the Oriental and earlier Euro-
pean process, the design was cut on the side or plank grain
of blocks of cherry or pear wood with knives and gouges. In
the latter part of the eighteenth century an English printer's
apprentice, Thomas Bewick (1753-1828) began engraving on
the end-grain of boxwood blocks with burins. These tiny
solid chisels differ from the sort used to engrave on metal
only by the angle to which they are sharpened. Bewick's
own work covered an enormous range, from tickets and
labels to large, detailed prints of birds and animals. He is
best known for his suites of prints of birds and animals
which he published in large volumes and sold very readily.
From Bewick's time to the latter part of the nineteenth
century wood engraving was used primarily for commercial

purposes such as the reproduction of paintings in the catalogues of public and private collections, the illustration of books, newspapers, and advertisements. There were a few notable exceptions, including the elaborate colour prints of George Baxter (1804-1867) whose artistry and skill have not been widely recognized. Wood engraving was then generally replaced by the appearance of photo gravure, only to re-emerge as an artist's medium in the rebirth of fine printing by private presses, most notably the Kelmscott press owned and operated by William Morris (1834-1896). Although Morris drew and engraved some blocks himself (there seems to be very little in the field of arts and crafts he did *not* do himself), he relied on his friend, Sir Edward Burne-Jones, for much of the design, and on the Dalziel brothers for most of the engraving of the borders, decorative initials and illustrations for his editions. Private presses with more modest budgets, such as Lucien and Esther Pissarro's Eragny press or the Vale press operated by Charles Ricketts and Charles Shannon, usually completed all the work including the design and cutting of blocks themselves. In Canada wood engraving has few champions: many have tried it but

 only a handful of artists chose it as their principal medium. Walter J. Phillips (1884-) and H. Eric Bergman (1893-1958) are among the best known. Bruno Bobak (1924-), Thoreau MacDonald (1901-), Leonard Hutchinson (1896-), Laurence Hyde (1914-) and Julius Griffith (1912-) have all worked on end-grain wood. Rosemary Kilbourn (1929-), though perhaps better known for her work in paint and stained glass, has produced what I feel to be the most exciting contemporary work in this medium in the country.

At a recent exhibition of the Society of Wood Engravers and Relief Printers in London, England (August 1977), I

saw not one print that could be called non-objective. Whether this reflects an overly conservative and tradition-bound attitude on the part of the wood engravers to their work, or whether it may be attributed to an honest recognition that this medium is indeed best suited to representational modes of expression, I am not prepared to decide. My own single foray into non-objective design was most unsatisfying and I have no intention of pursuing that direction. On the other hand, the close relation of black-and-white visual imagery with literary imagery seems to me a limitless field. The selection of poems or prose and the appropriate engravings is not always easy. Since the engravings are precise, definite and linear there must be something of the same in the words. The misty convolutions of psychological exploration seem to be more or less incompatible with engraving.

This comfortable connection between wood engraving and the printed word is only one of the reasons that I prefer to present my prints in books rather than in frames. I am 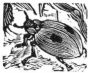 happiest when working at a small scale, both because my ideas for prints are usually such that they will fill only a small space and because, in a small design, each stroke of the burin counts for a great deal more than simply contributing to a large area of texture. Small prints should be looked at from a short distance and with good light: one is more inclined to take a book to a window and hold it at a good angle than is one with a framed print. Any pictures on the wall are inclined to become over-familiar, while a book, opened on the occasions when the urge is felt, remains less of a worn experience. Books allow one to see the prints without the barrier of glass and its inevitable reflections or distortions and to look in a book is usually a private and intimate experience — one holds and touches the print rather than standing back at a polite distance as in a public gallery. Altogether I find that looking at prints in a book is the most

satisfactory way to enjoy them. I would not want to suggest, however, that a book is merely a preferred alternative to a frame as a presentation for prints. When I plan a book I plan a sequence of communication, an experience with an element of passing time, a production with a beginning, middle and end, with a certain rhythm and climax, much like a small theatrical production. I also see the book as an important object in itself, a tactile and three-dimensional being. The book is not merely a container holding a number of small works of art — it is a work of art. And further, a book is, to me, a social creative event, a collaboration between several people, blending their ideals and skills.

 When I began my art studies I had never heard of wood engraving. I had done a few lino-cuts and woodcuts, but the inherent coarseness of those media left me dissatisfied because of my pleasure in small detail. I looked forward to etching, in which I knew fine detail was possible, but was disappointed when I found it necessary to work with dangerous and foul-smelling acids, and distressed by the 'feel' of working with metal. Then, too, there was the further obstacle of the need for a costly etching press to proof the plates. Imagine my delight on being introduced to a medium which allowed me to include every tiny line and dot the eye could see and yet work in the most responsive and congenial material I knew — wood. For several years I proofed my blocks and printed my editions by burnishing (rubbing the back of the paper with a wooden spatula) until 1971, when I acquired an Albion hand-press.

My working methods have not changed much since I began, though the finished products have showed variations in style. I make preliminary sketches, usually in pencil, in front of the subject, only rarely trusting my memory for

accuracy of form and detail. I have great difficulty in using photographs as a means of collecting information about subjects because they do not allow the editing and selecting possible in a sketch. Photographs, I find, are most useful to recapture the feel or atmosphere of a time and place. Only occasionally do I draw directly from the subject onto the block without an intervening sketch. In the case of buildings or specific landscapes or asymetrical objects, I must reverse the drawing so that it appears in 'mirror image' on the block. Botanical and wildlife subjects are not normally reversed. My drawings on paper or on the block are very sketchy, defining outline and tone but avoiding specific texture. If I were to produce a very precise drawing on the block, I fear that the engraving process would become mechanical, and thus, boring. I want the cutting of the design to remain as free, challenging and creative as possible. So many people observe, when looking at a completed block, that it must require a good deal of patience to produce one. My invariable reply is 'No'. Good eyesight and a steady hand, yes, but not patience. I enjoy chipping away at a design immensely, though it can be very tense and tiring work, as a slip of the tool will usually destroy the design and each stroke of the burin must be accurately determined. Lines cut into wood cannot be erased as those that are drawn onto paper with pencil. I try to engrave not more than three or four hours per day, using the remaining working hours for the many other activities of a working studio.

Every stroke of the burin produces a white mark in the finished print since, in wood engraving as in other 'relief' printmaking processes, the ink is rolled onto the surface of the block. This means that the black lines of the drawing are left standing and everything else cut away — a kind of 'negative' drawing. This process pleases me particularly,

since I am introducing light into an otherwise dark space. To render light dark is to do the devil's work: to bring or add light has more positive connotations. The length of time it requires to engrave a block depends more on the amount of white in the design and the fineness of texture and detail than on the actual size of the block. There are no grey tones in wood engraving, as all the printing surface is covered with black ink. The subtlety of cutting fine textures may suggest grey tones to the eye and mind, and small areas may be slightly lowered with a chisel prior to engraving so that they will print with slightly less pressure and appear grey.

The printing of these blocks is a less routine matter than might be expected. Some blocks print best when inked lightly and printed firmly: others are better inked heavily and given what printers call a 'kiss' impression. Some are well suited to being printed on the somewhat rough-surfaced European papers whereas others call for a polished tissue of oriental mulberry fibre. Almost all printing is facilitated by a more than usually humid atmosphere and fairly warm temperature. Predictably, there is no agreement among printmakers or collectors as to which impressions are 'best': one will prefer a very black print while another will choose an impression that allows the texture of the paper to show through the ink — a 'lean' impression, I call it, and usually the sort I look for when selecting a print for my own collection. Invariably some impressions will have to be discarded, either because of faulty technique such as over- or under-inking or because some flaw in the paper not noticed earlier becomes apparent when the print is made. Fortunately, there is almost no limit to the number of impressions that can be pulled from a well-cut block of sound boxwood. In contrast to a copper plate worked in dry point, which may yield as few as twenty impressions before wearing of the plate becomes offensive, end-grain blocks

12

have been known to produce over a hundred thousand clear impressions. The limiting of editions from these blocks is therefore a more or less artificial exercise, done perhaps to increase the selling price of the prints (usually demanded by dealers and collectors who see art primarily as investment) or because the artist is not eager to subject himself to the tedium of printing thousands of nearly identical impressions but wishes instead to move on to new work. It is usual to have blocks that are not to be printed again planed down and polished so as to extend use of the rare and precious boxwood.

<div align="right">

G. Brender à Brandis

</div>

Vine

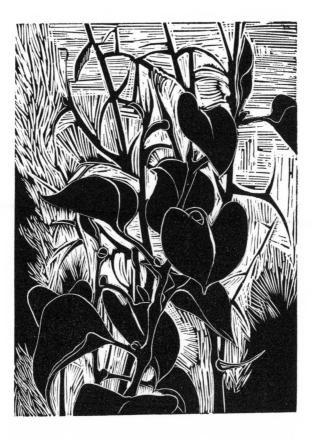

Dune Rose

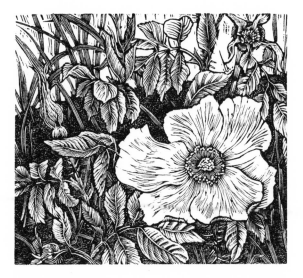

Cyclamen

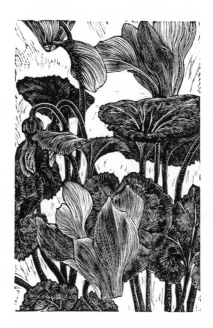

Dutch Farmstead

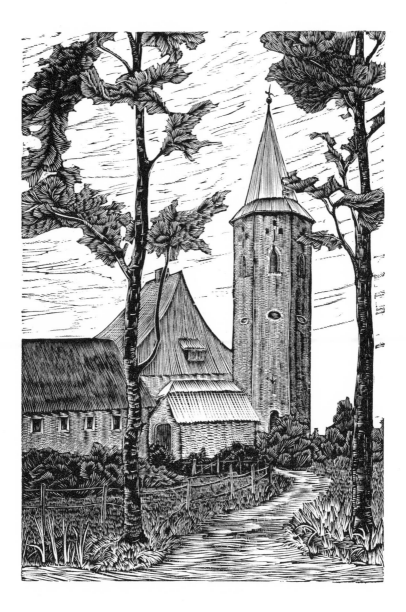

Bantams

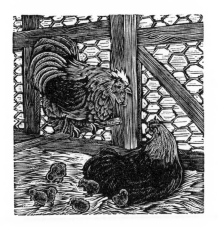

Smock Windmill, Cape Cod

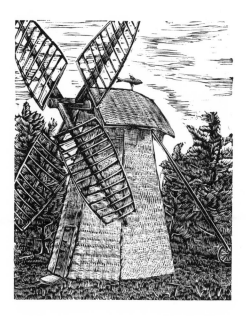

Kite

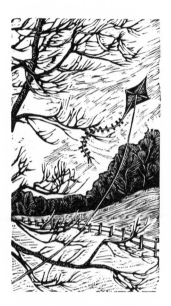

Broken Mill

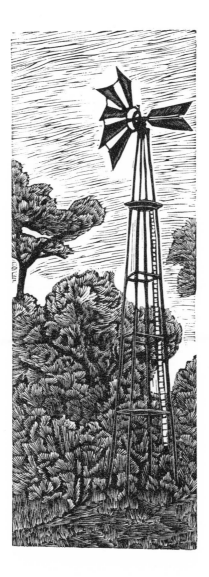

Flax

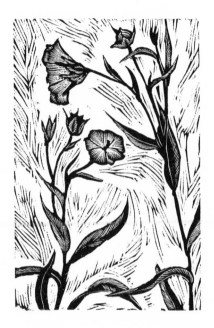

Wheat

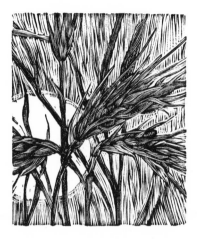

Bamboo

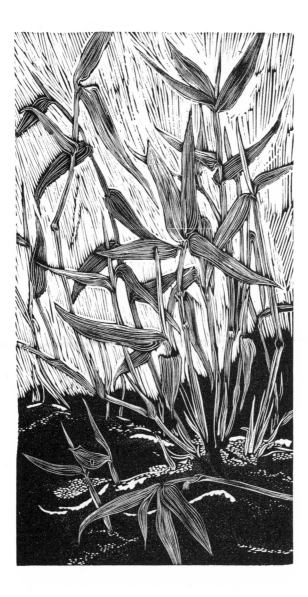

Rabbit

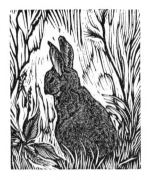

Rabbit

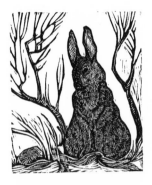

Monarch

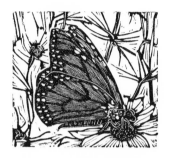

Lilies

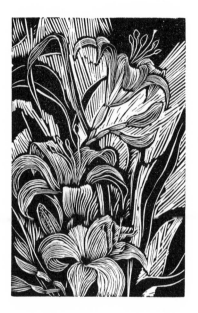

Primroses

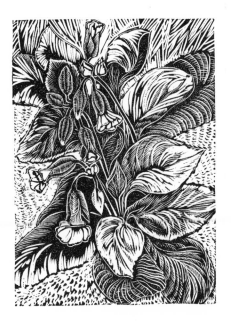

Trilliums

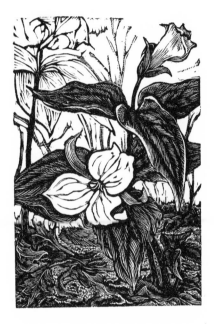

Daylilies

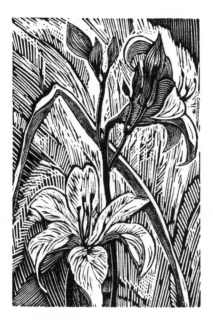

Snail

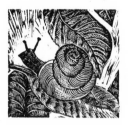

Frog

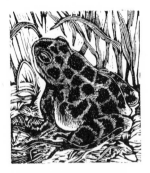

Lily Pond

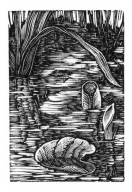

Marsh

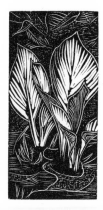

Winterton, Newfoundland

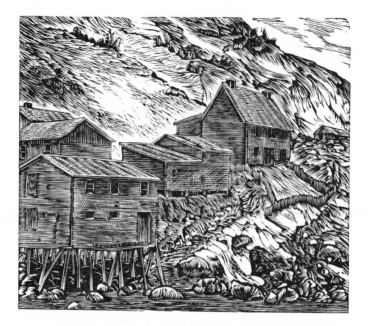

Salvage Prince

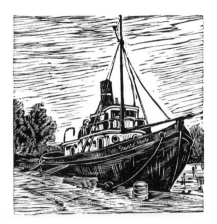

Schoolhouse at Valens

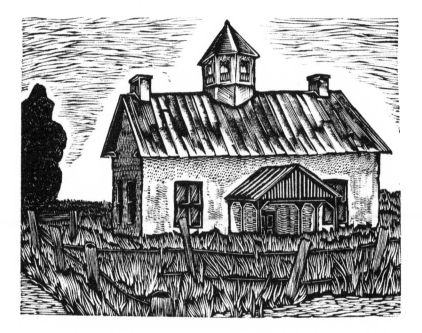

Churchyard

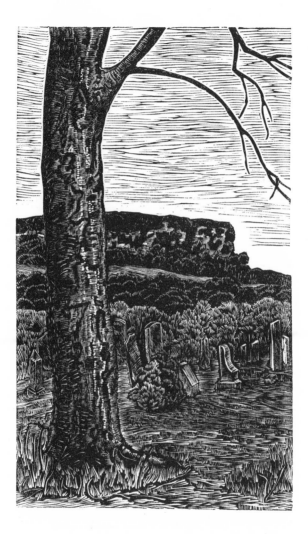

Saw-whet Owl

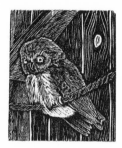

McCartney's Milkhouse

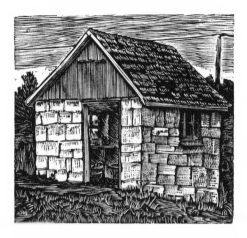

Pekoo

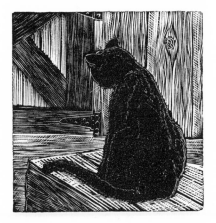

Barrel

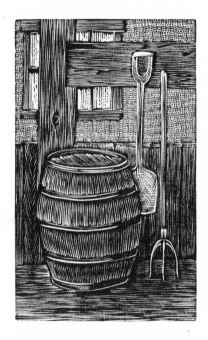

Bucket

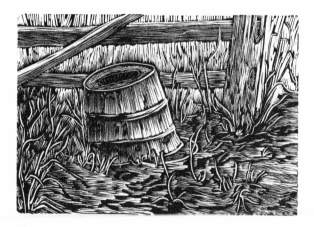

Chopping Block

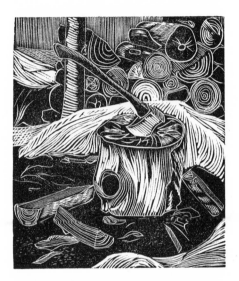

Sugaring

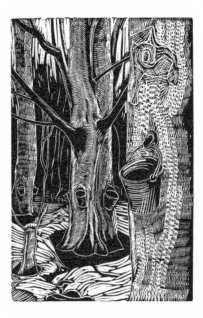

Water Trough, Progreston

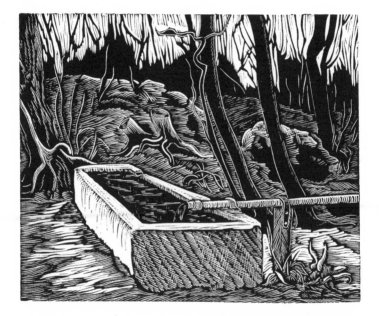

Making Butter

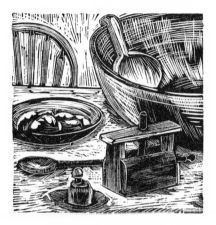

Kitchen Corner

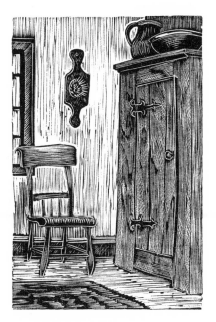

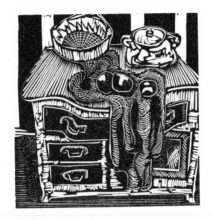

Untitled

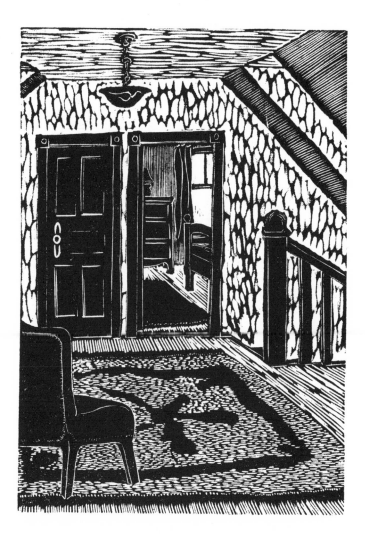

Fancy in the Rocker

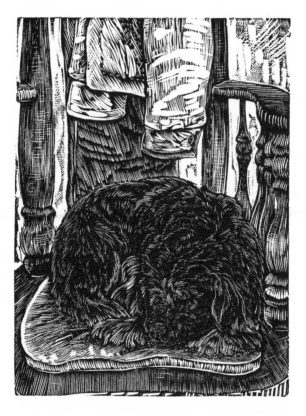

Windowsill

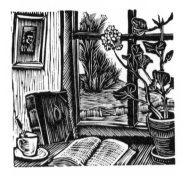

Untitled

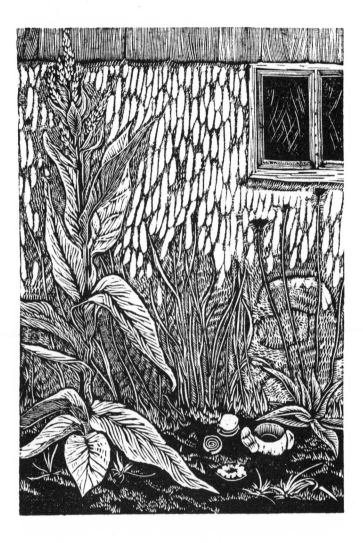

Tiger Lilies

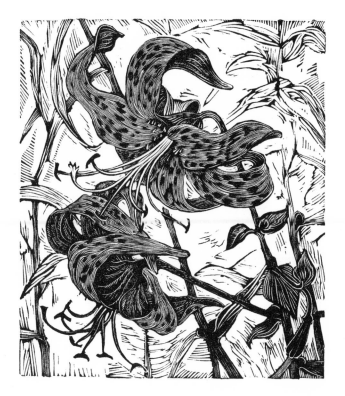

Glacier Lily

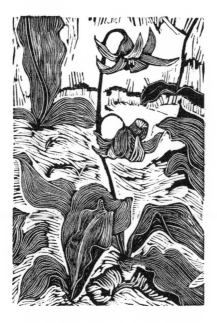

Pitcher Plant

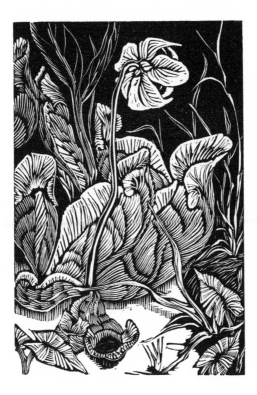

Jack-in-the-Pulpit

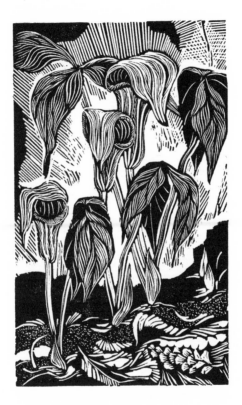

Hepatica

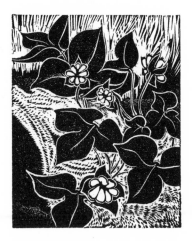

Lung Wort

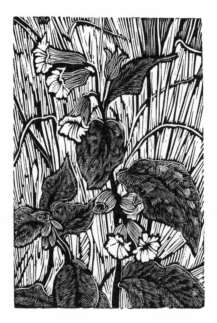

Bloodroot

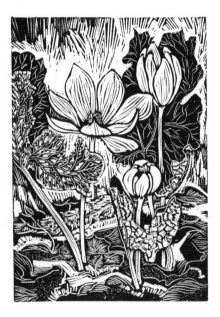

Striped Coral-Root

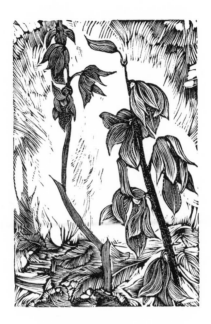

Trillium

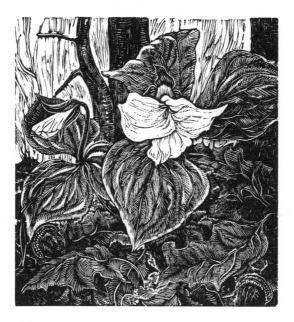

Ponderosa

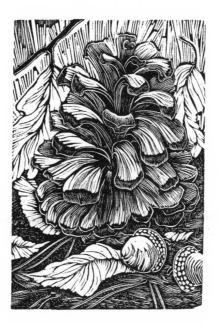

The Gift

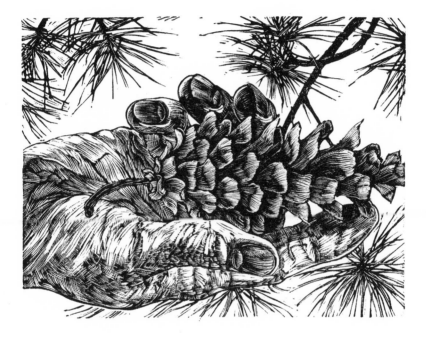

Calypso

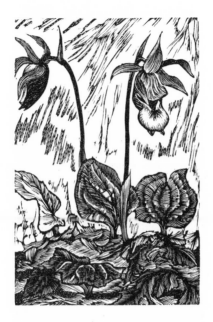

Chrysanthemums

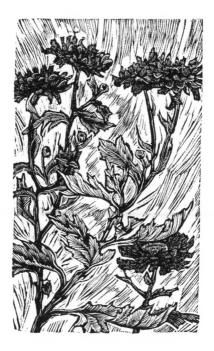

Snapdragons

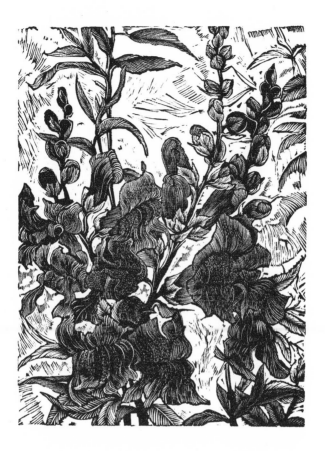

Poetaz Narcissus

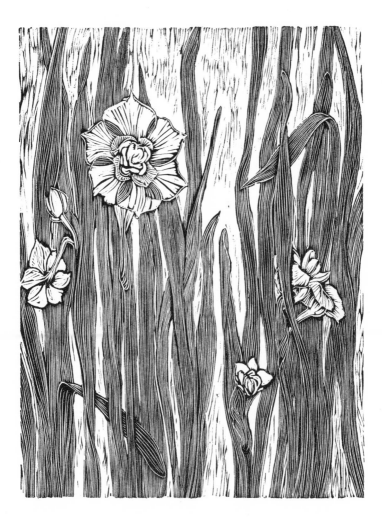

House in Eastview

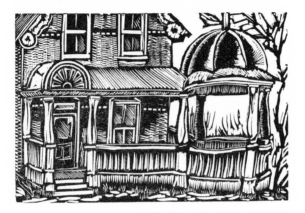

Gunby House

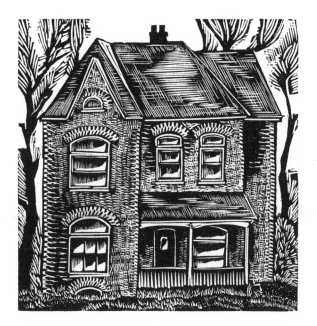

Window on Church Street, Toronto

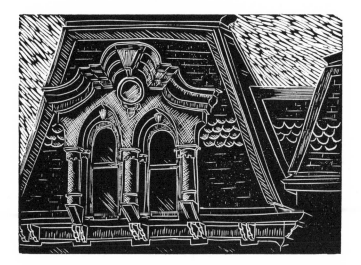

Irish Harp

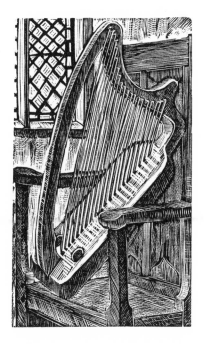

Virginal

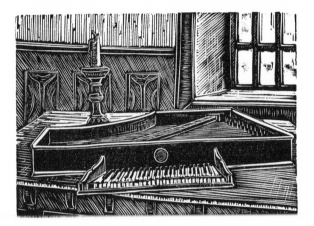

Viola Da Gamba

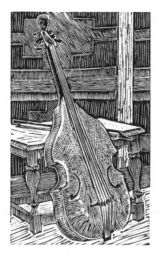

Recorder, Psaltery & Rackett

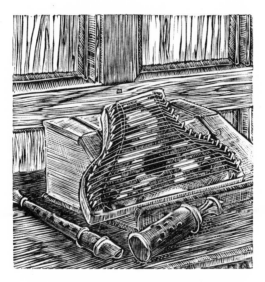

Catherine's Table

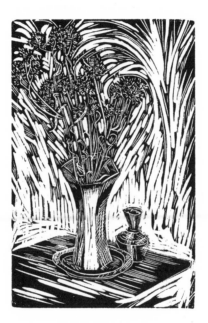

Winter Poems

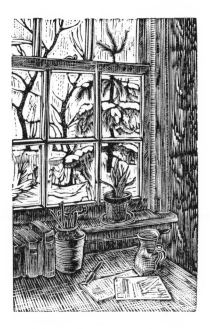

Crocuses

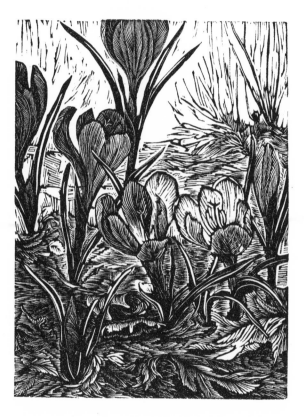

Dandelion

Lilacs

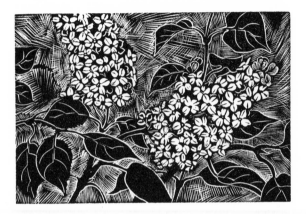

Peonies

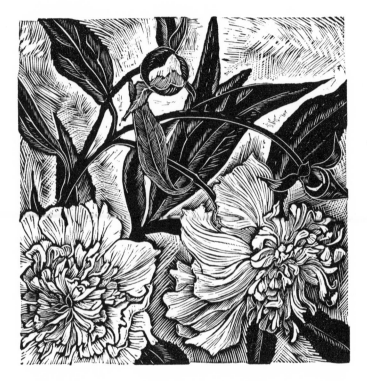

Foxgloves

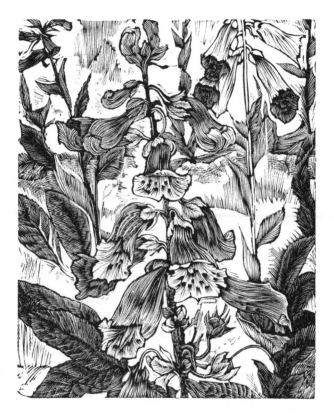

Black-Eyed Susan

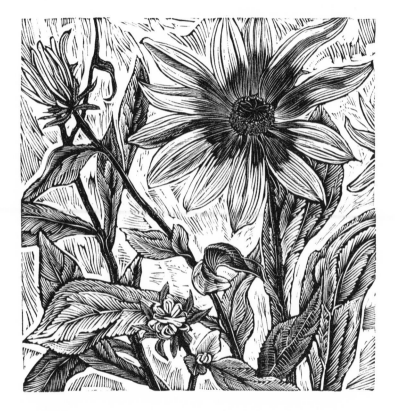

Gerard Brender à Brandis: born in the Netherlands to a family originating in medieval Switzerland, Gerard Brender à Brandis came to Canada in 1947. In addition to a B.A. in Fine Arts History at McMaster University in Hamilton, he followed several courses in summer schools in Ontario. After graduation in 1965, he set up his own studio in Carlisle, Ontario, where he continues to live and work.

Still concentrating on wood engraving, he has been moving away from larger prints for framing to smaller work presented in limited editions of hand-made books, with unnumbered impressions for framing from the blocks, both to make the engravings more widely available and to preserve his books from being dismembered. With occasional help from an assistant, his studio now has facilities for papermaking, typesetting, printing and binding of the books, as well as the spinning, dyeing and weaving of flax for some of the bindings. At present only a small percentage of the books are issued on paper made in the studio. Almost all the prints and books are issued on hand-made papers, some Canadian and some imported. Although the *livre d'artiste* does not yet have the established place among Canadian printmakers that it has in Europe, he hopes to see more exhibitions in future include this intriguing alternative to the framed print.

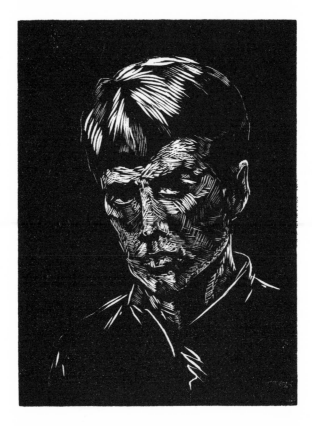